FESTIVAL
OF INDIA
1 9 8 5 - 1 9 8 6

INDIAN ART TODAY

Four Artists from the Chester and Davida Herwitz Family Collection

LAXMA GOUD

MAQBOOL FIDA HUSAIN

K. G. RAMANUJAM

SAYED HAIDER RAZA

THE PHILLIPS COLLECTION

WASHINGTON, D.C.

FEBRUARY 22–APRIL 6, 1986

Published by

The Phillips Collection

1600 21st Street, N.W., Washington, D.C. 20009

© 1986 by The Phillips Collection. All rights reserved.
Designed by Stephen Kraft
Photographs courtesy of Chester E. Herwitz
Printed by Garamond Pridemark Press, Inc.,
Baltimore, Maryland

Library of Congress Cataloging in Publication Data

Phillips Collection.
 Indian Art Today: Four Artists from the Chester
and Davida Herwitz Family Collection.
 A catalog of an exhibition held at The Phillips
Collection February 22–April 6, 1986
 1. Art, India—Exhibitions. 2. Art, Modern—20th
century—India—Exhibitions. 3. Herwitz, Chester—
Art collections—Exhibitions. 4. Herwitz, Davida—
Art collections—Exhibitions. 5. Art—Private
collections—United States—Exhibitions.
I. Phillips Collection.
N7304.152 1986 760'.0954'0740153 85-32106
ISBN 0-943044-07-3 (pbk.)

Foreword

Several years ago, when India's extraordinary cultural minister without portfolio Mrs. Pupul Jayakar told me about plans for the Festival of India, I said that The Phillips Collection would like to participate by mounting an exhibition of early modern or contemporary Indian painting. We then discussed the exciting possibility of my visiting India one or more times to select the works.

Six months later I indeed found myself in a crowded factory warehouse surrounded by leather handbags and hundreds of paintings by twentieth-century Indian artists. It was total cultural immersion, made intelligible by a pair of informed and articulate collectors.

But instead of being in the heart of India, I was just off a freeway in the heart of Worcester, Massachusetts. And the articulate collectors were Americans, Chester and Davida Herwitz, who have slipped away from their manufacturing business for six weeks in each of the past twenty years to visit India and acquire contemporary Indian art. Since they have formed one of the world's best collections of such art, there was—alas—no need for me to visit India.

The Herwitz Collection made it possible to see a broad spectrum of Indian art—some twenty artists, each represented by numerous works. My selections of the work of four artists was based on the type of considerations we normally apply to loan exhibitions: that the artists have some affinity with those represented in the permanent collection of this museum; that the artists have a unique, personal esthetic vision; and in this case that that vision strongly reflect their Indian cultural heritage and not simply the prevailing international art movements.

We are most grateful to Chester and Davida Herwitz for so generously lending a substantial body of their collection to this show and in many cases preparing the works for exhibit. We are delighted that Indian Ambassador K. Shankar Bajpai is serving as Honorary Patron of this exhibition and appreciative of all the assistance rendered us by the able members of his staff, especially Mr. Niranjan N. Desai, Minister of Culture at the embassy in Washington, D.C. Finally, we wish to thank Dr. Partha Mitter, Professor at the University of Sussex in Brighton, England, and Dr. Daniel A. Herwitz, son of the collectors and Assistant Professor of Philosophy at California State University, Los Angeles, for their catalogue essays.

Laughlin Phillips, DIRECTOR
THE PHILLIPS COLLECTION

Indian Art Today

Partha Mitter

The present exhibition of paintings, drawings, and prints by four Indian artists, Maqbool Fida Husain, Sayed Haider Raza, Laxma Goud, and Ramanujam, is based on one of the major private collections of modern Indian art in the West, assembled by Chester and Davida Herwitz. The works form a small part of the main collection, acquired with as much discrimination as devotion over a period of several decades. The choice of these four artists is particularly interesting. Each has an individual signature but they also complement one another. The common thread is their "Indianness," even though Raza lives in Paris and Husain spends a great deal of time abroad. The most celebrated among them is Husain, the doyen of Indian art who, with Raza, belongs to the older generation. Raza, in his turn, enjoys an enviable European reputation. Husain and Raza originally belonged to the Bombay art world, founding the Progressive Artists' Group just after India gained independence. To the younger generation belong Laxma Goud and the tragic K. G. Ramanujam. Goud, though he is from Hyderabad, received his intellectual nourishment from the well-respected art teacher K. G. Subramanyan in Baroda, while Ramanujam was a pupil of the noted painter K. C. S. Paniker of Madras. Apart from Raza, who draws inspiration from landscape and city life, these artists have the human form as their central preoccupation. Of the four, Goud's special strength is the line. The other three are primarily painters, although Husain's prolific output includes photography and film making.

India is a country where traditional art still plays a significant role. In India, as in the West, important changes took place in the 19th-century, even though traditional industrial arts, now in decline, still continued to be produced. The colonial period, which introduced Western academic art in India, was responsible both for the rupture of tradition and the end of the traditional artist's role. A significant development during the British Raj period was the shift in class affiliation. The earlier artist, who had the status of an artisan, gave way to the "gentleman" artist. During most of the freedom movement, artists came from the Western-educated elite. This situation began to change during the 1940s with the emergence of artists whose origins were less privileged. Most notable among these is Husain. This process of democratization helped reintegrate people from all walks of life into Indian art, an expansion of the rather narrow—though interesting—horizon of early 20th-century Indian art. I do not wish to give the impression that early movements were not important, for after all, present art movements in India were built upon the foundations of the earlier periods. Nonetheless, beginning in the 1940s, art gained a new richness. At the same time it is worth remembering that even the new artists from the lower-middle or working strata could not simply return to the older folk and popular arts of a traditional society. There is a world of difference between the outlook of the traditional village artist and that of the individualistic, Western-educated artist. Innocence, once lost during the colonial era, could never be recovered. On the other hand, there arose conflicts between East and West, tradition and modernity, rural and urban life. Above all, the search for identity and a sense of alienation from rural India are factors that make the new art all the more interesting, not least through the tensions generated by these contradictory pulls.

In 1947, as the British Raj retreated, independent India began its new life. The artists no longer felt the need to make the overt nationalistic statements that were considered necessary before independence. While artists from the upper classes had dominated the art world of India prior to the 1940s, such artists as Husain represented a new generation that brought new attitudes and sensibilities to Indian art. Of this generation, Husain is generally accepted as the most eminent. Born in 1915, in the Pandarpur village of Maharastra, Maqbool Fida Husain received only sporadic art training in the Indore art school. He then moved to Bombay, where he lived eighteen years in poverty. The city's slums scarcely offered any privacy for him, his young wife, and his children. He eked out a living, painting cinema billboards, those gigantic examples of "pop art" that dominate Indian cities. Working on such a large scale gave him the skill to switch with ease from small miniatures to the large murals created later in his career.

In 1947 he formed the Progressive Artists' Group with other like-minded painters. Recognition from the cosmopolitan Bombay society followed soon after. A radical expansion of his horizon took place in the 1950s when he began to travel abroad. This coincided first with national awards and official honors, followed by recognition in the West. The climax of Husain's career came with the homage paid him at the 1971 São Paulo Biennale, where his retrospective shared the exhibition space with Pablo Picasso. Another indication of his international status is the fact that he is the only Indian artist who has had a substantial biography published by a leading publisher of art books in the West.

What constitutes the Husain "magic"? It is a combination of two factors: the man and his works. It has as much to do with his proverbially striking looks—he bears an uncanny resemblance to an Old Testament prophet—and his unconventional temperament, as with the prolific range of his *oeuvre*. This was recently exemplified in the brilliant series of photographs parodying Hindi billboards, where he takes a fond, if ironic, look at the art form with which he began his career. Husain is at home in Western cosmopolitan circles, showing deep appreciation of the avant-garde film, especially Jean-Luc Godard. His own film *Through the Eyes of a Painter* won an award in Berlin in 1968. Yet for all his sophistication he is at heart a simple man and has no difficulty relating to the ordinary village folk. His sympathy for the common man comes across forcefully in all his activities. At the same time his constant, almost obsessive, peregrinations across continents release him from narrow cultural parochialism.

Husain's ability to leave one mode of expression and enter another has become a matter for intellectual debate. As his biographer E. Alkazi has written,

In sheer output, in the range of his themes, the quality of excellence which he has maintained over three decades, he rises above his peers. . . . For critics he remains an enigma . . . They have barely been able to categorize one phase of his when he has stormed his way into another.

Geeta Kapur on the other hand feels,

One can only ask of him what his own work promised: authentic understanding of the traditional—the "typical"—Indian. . . . Having recognized it with something of a brilliant intuition, having embodied [it] in a series of lucid and memorable images, he let go of it, too soon and too easily.

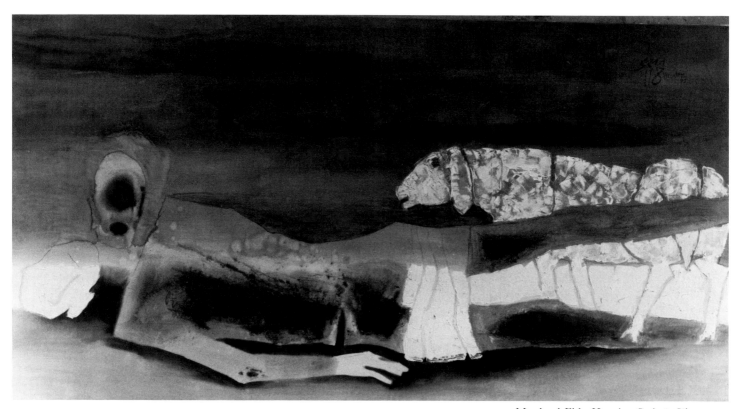

25. Maqbool Fida Husain, *Cyclonic Silence*, 1977

The most remarkable feature of Husain's paintings, which has remained a constant from his earliest period when he was creating fresh images of the Indian village, is a mythic quality in a land which has thrived on myths since time immemorial. So it was no surprise that he moved on from a depiction of village life to actual representations of the perennial myths in Indian culture, as stored in the two great epics, the *Rāmāyana* and the *Mahābhārata*. With penetrating imagination he was able to go beyond the particular and the contingent to fashion universal statements and distill essences. Hence his figures, especially the human form, are Platonic types. In his major series he has been able throughout to create a complex iconography of "hieroglyphs." For instance, feeling deeply distressed over the flood disaster in Andhra Pradesh, he

created a simple but effective symbol in his painting *Cyclonic Silence* (cat. no. 25) by placing a gentle lamb next to the naked corpse of a woman. This image suggests not only the terrifying silence after the cyclonic floods, but also a quality of submission. In his words, "even in the greatest tragedy there is always a ray of hope . . . I used just two symbols [here]—the female form [in destruction] and the innocent lamb. The lamb was always white. In the entire holocaust and destruction and unbelievable tragedy, the white lamb represents a sense of optimism, a ray of hope."

The Herwitz collection is so comprehensive as to afford insight into the individual quality of this painter's work. Instead of a chromatic approach to color, Husain prefers a narrow range of bold hues that bring out his essential pictorial vocabulary. Husain's aims have affinities with Chagall's creation of a visual language from Jewish folklore. In fact, one of his concerns has been the interaction between the people and their environment, expressed through a stylized shorthand, highlighting individual limbs, hands, eyes, or toes. Yet he avoids a rigid schematization by adopting free and random associations between objects, figures, and their background. Nor should we overlook the effective use of space and the various, sometimes overlapping, planes of his pictures. Remarkable too are the transformations of the traditional Mathura figure sculptures that he first introduced in the late 1940s. Husain's interest in the figure springs as much from the Indian tradition as from his humanism. He has faced tragedy in his own life, the most poignant being the death of his little son in an accident. But like many truly creative people, he has been able to transcend individual tragedies and transmute

them into universal statements. Perhaps no other artist in India has this ability to capture the essence of things.

The recurrent images of horses and of women, as expressed in Husain's work, have now become part of the general Indian visual language. His bold statements about the human condition can be found in *Cage III* (cat. no. 22), the third painting in a series that skillfully combines the flat treatment of figures with a decorative background consisting of bright orange, pink, yellow, and subdued grays. Utterly different in style are the stark serigraphs of genre scenes from Benares, inscribed with the city's alternate name Varanasi. Here the objects have been reduced to the level of pictograms by means of wiry, nervous lines, such as the corpse waiting to be burnt in *Benares IV* (cat. no. 17), or the body floating in the Ganges River, depicted in *Benares VIII* (cat. no. 21). In this image, the snake—a symbol of the god Shiva—and the spraying water allude to the legend of the "Descent of the Ganges." These ambitious series, based on the *Mahābhārata* and the *Rāmāyana,* reflect the spirit of ancient India and have engaged Husain's interest for over a decade. They are purposely the most schematic, in accordance with the mythic nature of the texts. One of the most delightful is the 1976 painting *Arjuna and Washington* (cat. no. 24), a powerful composition with a dramatic combination of glowing reds, whites, yellows, and blues, that takes as its point of departure the early paintings of battle scenes from Mewar, a region in Rajasthan.

If Husain's art can be called the work of an extrovert who celebrates life and its myriad pleasures, Sayed Haider Raza's chromatically balanced, quiet paintings reflect an introspective,

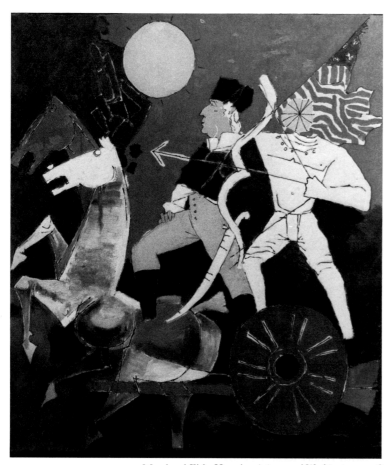

24. Maqbool Fida Husain, *Arjuna and Washington*, 1976

contemplative temperament. In the following passage he offers us a tantalizing glimpse of the source of his inspiration:

The most tenacious memory of my childhood is the fear and the fascination of the Indian forest. . . . Nights in the forest were hallucinating; sometimes the only humanizing influence was the dancing of the Gond tribes. Daybreak brought back a feeling of security and well-being. On market day, under the radiant sun, the village was a fairyland of colors.

Landscape has remained Raza's abiding inspiration. He was born in 1922, the son of a forest officer in Madhya Pradesh. Slightly earlier than Husain, he made his debut in the Bombay art world, coming to the notice of the critic Rudolf von Leyden, who became his fervent champion.

In evaluating Raza's career in 1959, von Leyden divided it into four phases. Raza's earliest works were essentially cityscapes of Bombay, concentrating on the shapes of buildings, cars, and the teeming population. He started using color in a non-referential way that brought out the essential character of each color, demonstrating a strong architectonic sense. Gradually he began to develop a more intense vision of his city, capturing its moods at different times of the day and in different seasons. However, he did not confine himself to Bombay but traveled the length and breadth of India, discovering its landscape and the variety and diversity of its flora and fauna. These were the years of intense activity, when he produced an enormous quantity of canvases, holding frequent one-man shows, and recording the richness of the visual world. This phase began to yield to the search for an inner world of reflection, with its concern for pure space, line, and color, seen for instance in the 1948 Kashmir series. By this time he began to be drawn to the cosmopolitan art world of Paris, a city that had inspired most Indian artists of his generation. It was not until 1950, however, that he set sail for France.

The first years in Paris were lonely and hard but they had a liberating effect on Raza and his work. The poetry and simplicity of Medieval and early Renaissance paintings appealed to him in their lack of rhetoric. Out of the new experience came the striking series of landscapes consisting of houses constructed with mathematical precision, suspended in empty spaces. He impressed the critic Jacques Lassaigne, who writes,

It was in 1952 that I first saw the works of Raza, recently arrived in Paris from India. The works were strange, unusual, timeless landscapes, uninhabited cities detached from the earth, bathed in a cold light. Schematic houses were linked to one another in an endless chain suspended in the air beneath a dark sun.

These paintings were also vivid reminders of the fierce sun-soaked Rajasthani landscape, as depicted by the painters of that region. The meticulously constructed miniature watercolor landscapes were soon to give way to oils. This period was to lead to his renown in the West as a major painter. He became the first non-French artist to receive the French *Prix de la Critique* in 1956. His colors, until then rather subdued, soon became a riot of blazing vermillions, mustard yellows, Prussian blues, and strong blacks. Lassaigne characterized this period as a world dominated by the powers of light and shadow.

The essential feature of Raza's paintings is "transfigured nature," a continuing personal commitment to a mysterious, metamorphosed universe. The earliest canvases dating from the 1960s contain violent clashes of colors. They remind us of the brightly-clad peasants of Rajasthan under a blinding sun. A most effective example is *L'été* (cat. no. 53). Although nonrepresentational, the composition has the power

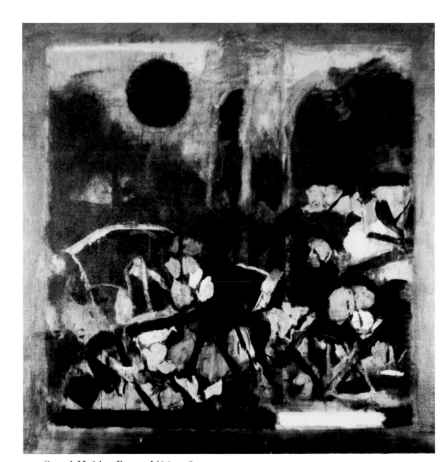

53. Sayed Haider Raza, *L'été*, 1967

to evoke the relentless, scorching heat of the Indian summer. Raza here consciously allies himself with the mode of combining warm and hot colors, developed by the 18th-century courtly painters of Basoli in northwest India. Significantly, he returns to these traditional artists yet

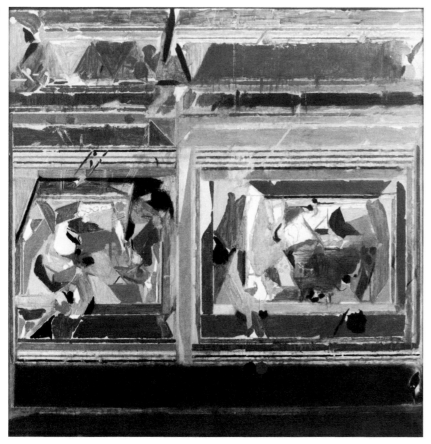

58. Sayed Haider Raza, *Rajasthan II*, 1983

strong emblematic nature of these diagrams or *Yantras*. Nature, which has served Raza as a metaphor, could now be further explored in art based on *Tantra*. One such example is *Bindu, La Terre* (cat. no. 55). The upper half of the painting is dominated by a blue-black circle, relieved by the primary colors red, blue, and yellow while the lower half contains a series of bands, each with its subtle gradations of color values, especially browns and grays. These as well as the paintings inspired by Rajasthan bring out Raza's supremacy as a colorist.

Both Husain's and Raza's works gradually acquired a cosmopolitan and universalist flavor. On the other hand, Laxma Goud and Ramanujam, two artists of the younger generation, search for expressions that have indigenous qualities. They also move towards a more narrative form of art. Laxma Goud was born in 1940 to a rural family of toddy-brewers living in Nizampur in Andhra Pradesh. After attending the art school in Hyderabad, he moved to Baroda in 1963 to learn mural painting with K. G. Subramanyan, who encouraged him to develop his own personal vision. His acquaintance with the artistic community in Baroda helped him to broaden his intellectual horizon. As Ghulam Sheikh writes, "he came to realize the basic problems in life and art as an individual."

He was soon to discover the vitality of Indian village life. The individualism fostered in art schools paradoxically enabled Laxma for the first time to see his own village background in a new light—both as an insider and an outsider. As he became aware of his own burgeoning sexuality, he recognized the raw, uninhibited sexuality of the villagers, so unlike the strict rules of decorum that govern the sexual mores of the middle class-

again in the 1980s, paraphrasing the Basoli renderings of the *Rasamanjarī* text in *Rajasthan I* (cat. no. 57) and *Rajasthan II* (cat. no. 58). The magic diagrams belonging to the *Tantra* cult of Hindu and Buddhist religions—recently rediscovered by the West and the East—have been a powerful inspiration for the Indian artist because of the

es. In an interview with Hans Winterberg, Laxma confides,

After I came home in 1965, I went around in the village where I had grown up. . . . I remembered my childhood . . . [and] certain events and experiences . . . of an erotic nature . . . Perhaps you know that many taboos and inhibitions characteristic of the relations of the sexes in the upper strata of society in urban areas are not to be found in the Indian villages. People living closer to animals, seeing them copulating and giving birth, have a very natural attitude towards sexual phenomena. I remember women abusing one another with plain sexual gestures and words, but without any awkwardness.

Not only did the theme of village and tribal life dominate his work right from the outset, but he seemed to wish to "emancipate" the elite from their sexual inhibitions and restore the frank eroticism that existed when Hindu erotic temple sculptures were produced.

Laxma's teachers were the first to notice his exceptional draftsmanship. Incisive, at times even cruel, lines and a keen eye for detail have been his particular forte. Naturally, pencil drawings and graphic works turned out to be his ideal medium, due to the concentrated effect they can produce, an effect that can only be diluted or even destroyed by the addition of color. This monochrome austerity which has a bite and verve his colored works cannot match, prevents his work from descending to the level of cloying sentimentality—a drawback often suffered by the romantic "primitivism" of modern artists. Laxma further distances himself from his erotic subjects by periodically introducing into his works the comic and the grotesque.

After a period of working in an expressionist-surrealist style, Laxma evolved a narrative mode based on the free association of images depicting human and animal passions that did more justice to his creativity. Now, he found, "the landscape forms became identifiable and animals and men began to assume [a] definite personal character as well as rational proportions." At the same time the erotic content of his work became more intense as explicit scenes of love-making predominated—arguably a political act on his part. The year 1975 saw a new departure, the introduction of fresh subjects—nails, scrap metals, tools, and the *objets trouvés* of wayside shops in India as shown in an untitled drawing (cat. no. 1) of the following year. Like Husain, he too responded with anguish to the victims of the 1978 floods in Andhra Pradesh, producing pictures of dead cattle and desolate men and women. As an Andhran, he felt personally involved.

In the present exhibition, Goud is chiefly represented by works from his mature years, a period when his initial violent expression had died down. Some of these works display a brilliant combination of textures; the figures are built up by deep shading and the skillful use of the variegated tones of lead pencils applied at different intensity. The richly worked figures create a dramatic contrast to the bare, absolutely blank grounds. There are villages, couples, lovers, human beings turning into trees, and interiors with scrap metals. Above all, there are striking images of tribal men and women, their faces sometimes seen in profile, gaunt, ravaged, not pretty in a conventional sense, but exuding a massive, monumental beauty; the ornaments worn by women are executed with closely-observed details, the surrounding plants, leaves,

and trees are represented with astonishing fidelity and richness. We see how Laxma Goud captures in his own personal way a segment of rural, primitive, and vital India, as filtered through his sardonic eye.

There now remains the tragic figure of K. G. Ramanujam (generally referred to by his last name alone). The youngest of the four artists, he had an all too brief and tortured life that was punctuated by a series of remarkable paintings. Out of the sufferings of this gifted painter emerged a certain grandeur and the unveiling of a strange world of the imagination. Born in 1941 to a poor orthodox Brahmin family of the south, Ramanujam took his own life at the age of 33. At the time of his death he was working on a canvas depicting a fantastic elephant. Stunted in growth, suffering from a speech impediment, he was a failure at school. His father took him to see K. C. S. Paniker, the head of the art school at Madras, who took to Ramanujam instantly. Ramanujam too responded to such caring on the part of the older painter and began to work prodigiously. Despite his handicaps, or perhaps because his disabilities gave him a more intense awareness of life, Ramanujam began to make great efforts to be sociable, taking up alcohol and cigarettes, renouncing vegetarianism. He was deeply attached to his father, whose death in his first year at school left a gap he could not fill. Desperately lonely, he often spent nights on the pavement of the streets while at school.

In 1964 he moved to the artists' commune at Cholamandalam. From this time onwards he began to be noticed by critics. Among his large-scale works, the mural at the Connemara Hotel in Madras is the best known. But he remained intensely lonely and desperately craved the love and friendship of the opposite sex. His friends advertised for a girl who might share his life, but without success. Ramanujam's loneliness led gradually to alcoholism and ultimately to his death. Ramanujam had difficulty in putting his inner feelings into words. In his touchingly faltering way he once confided to his mentor, Paniker:

The army of muses came in search of me from this shadow of the tree of shell. I looked on them in sadness. I rested in the palm of a hand and the creepers gave me shelter. Their memories heaped on me tier on tier, yet sweet the beloved burden.

His was a child's vision of paradise. The paintings were not at all the work of a melancholy man, but transport us to a colorful world of fable, of blue-eyed goddesses, reclining odalisques, and bizarre hybrid beasts, sometimes mounted on pedestals, of fantastic domed architecture with round arches placed at regular intervals, forming long galleries. He appears in most of his pictures, recognizable in his assortment of European hats. He is said to have been excited by a picture book of Venice that he had once received as a gift. Several works in the exhibition reflect images of that city.

He pored through Indian children's tales—especially the *Chandamama* series of Uncle Moon stories—through palmistry sets, and seashells to construct an utterly personal iconography with which to create a fairy-tale universe. On closer inspection we also find that many of his images are embedded in the sculptural and architectural traditions of southern India and in the glass paintings of the Tanjore district. Interestingly enough, the magic world he creates with often exotic elements is based on the forms and color

combinations that are to be found in traditional south Indian paintings.

In an almost literal sense, Ramanujam's paintings are the stuff of dreams. We know that every morning he would relate to his friends the dream he had the previous night. We do not need to invoke Freud to see them as wish fulfillments on the part of a lonely man. There are certainly recurring images of enormous serpents, but they are often funny rather than frightening. His serpents are based on the mythical serpents, the *Nagas*, of traditional Indian literature. The paintings functioned more as catharsis than as simple therapy. What makes Ramanujam's work different from the therapeutic work of the disturbed is his total artistic control of the medium. It comes as no surprise that he found James Ensor to be a kindred soul. In his paintings there are certain basic preoccupations, and certain images crop up with regularity. The paintings are often celebrations on a grand scale—festivals, processions, and carnivals attended by winged musicians and dancers in bizarre costumes. An untitled painting of circa 1973 (cat. no. 45) has the intensity and strangeness of Ensor's *Entry of Christ into Brussels*. A crowd is celebrating some unknown feast in a square dotted with high columns decorated with flying banners resembling wings. Behind the figures looms a giant serpent, but its scales are made up of pillars and other architectural elements. In the background are buildings; their style is a grand mixture of European, Muslim, and Hindu architecture, with profusely sprouting domes and multi-arched façades. The human figures in the square seem to have come from children's stories but are in fact based on south Indian images of gods, difficult to recognize out of context. Their staring eyes are

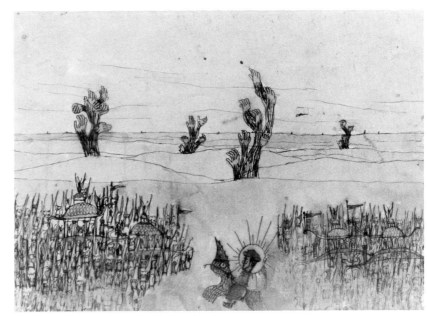

46. K. G. Ramanujam, *Untitled*, undated

similar to the great image of Jagannātha—the Juggernaut of European travelers—at Puri in Orissa. The tall columns have the same fan-shaped crowns to be found in south Indian temple gateways called *Gopuras*.

The wealth of detail that we see in this exhibition makes Ramanujam's work so fascinating. One untitled work (cat. no. 38) shows the ubiquitous spirit *Naga* who has a human face and who appears with a nude winged figure of a woman transformed into a fabulous monster. A watercolor and ink drawing on paper (cat. no. 47) shows a typical south Indian open pavilion in a square containing a sculpted animal on a pedestal. This tailed animal appears to be wearing

dark glasses, resembling film stars, the local public heroes. A festival is going on in the foreground: richly decorated fans are waved by revellers; and a "royal" parasol is held over the figure of the artist. There is an oil painting (cat. no. 36) showing the artist seated on a crescent moon with two blue-eyed beauties flanking him. The sun rises behind them. The staring eyes of the women once again resemble those of the icon of the god *Jagannātha*. Finally, the exhibition includes a landscape with monster cacti, their arms resembling human hands, the shrubbery in front concealing weapons of war and a pavilion (cat. no. 46).

The diminutive artist rides a hybrid creature somewhat like a lizard. A four-armed deity rides a strange beast, *Untitled* (cat. no. 34); a pagoda tower, festooned with gargoyles; a bird draws a chariot, *Untitled* (cat. no. 43). In their immense detail, these works offer a rich scope for the imagination, making more poignant the viewer's regret at the abrupt end of such a promising career.

Further Reading

ALKAZI, E. *M. F. Husain: The Modern Artist and Tradition.* New Delhi: Art Heritage, 1978.

ALKAZI, E. *Flickering Hieroglyphs.* Exhibition, Art Heritage, New Delhi, February 10–18, 1978.

BARTHOLOMEW, R. AND G. KAPUR. *Maqbool Fida Husain.* New York: Harry N. Abrams, Inc., 1971.

Chemould Publications and Arts. *Raza.* Bombay, 1985.

GAUTHIER, P. *Raza.* Bombay: Vakilis, 1956.

HUSAIN, M. F. *Story of a Brush.* Bombay: Pundole Art Gallery, 1983.

"On Life and Death and Art." Interview with M. F. Husain, Z (December, 1978):34–41.

Indian Council for Cultural Relations. *Contemporary Indian Painting.* New Delhi, 1973.

Indian Express, September 6, 1973:8–9.

KAPUR, G. *In Quest of Identity.* N.p.n.d.

LASSAIGNE, J. *Raza.* N.p., 1966.

LEYDEN, R. VON. "Sayed Haider Raza." *Sadanga* (April, 1954):3–20.

LEYDEN, R. VON. *Metamorphosis.* Exhibition, Gorbio and Bombay, September and December, 1978.

MITTER, P. *Much Maligned Monsters: History of European Reactions to Indian Art.* Oxford: Clarendon Press, 1977.

Museum of Modern Art, Oxford. *India: Myth and Reality.* Exhibition, Oxford, 1982.

NATH, A. "Faith in Creation." *India Today,* December 1–15, 1976.

SHEIKH, G. M. *Laxma Goud,* N.p., 1979.

The Tate Gallery. *Six Indian Painters.* Exhibition, London, 1982.

WINTERBERG, H. Interview with Laxma Goud, *Lalit Kala Contemporary.* (February, 1973).

Indian Art from a Contemporary Perspective

Daniel A. Herwitz

The Festival of India provides a timely context for viewing the four contemporary Indian artists on exhibition at The Phillips Collection. The festival's exhibitions of classical Indian bronzes, textiles, and miniature paintings allow one to approach these contemporary artists with a sense of the traditional. Against such a background, however, the contemporary work may appear as recalcitrant as it appears exciting; for, one may wonder what the modernist musical abstractions of Raza, what the activated cubist spaces of Husain, what the stitched figures of Laxma Goud or the personal mythology of Ramanujam have to do with their more ancient predecessors. Indeed one may wonder not only what these works have to do with traditional India but also what they have to do with each other. Husain's vibrant and whimsical line seems to bear little stylistic resemblance to the heavily drawn tribal figures of Goud; Raza's astringent architectural clarity seems to bear equally scant resemblance to Ramanujam's floating, nearly unhinged spaces.

If these artists are in fact isolated both from their traditions and from one another, then it will mean little to call them Indian and contemporary. Calling them Indian will imply that India is now isolated from its past, presumably with its artists either at work in some wholly international arena or (in the case of the late Ramanujam) in some wholly personal arena of fantasy. Calling them contemporary will mean little more, for if they share neither a cultural inheritance nor a set of stylistic norms and goals, then they will appear to be contemporary only in the sense of living at the same time. Yet one wants to mean something more by one's words when one claims that these artists are of a culture and a time—of India and the present—just as one wants to mean more by one's exhibition when one exhibits them together. It is what these artists have to do with their cultural traditions and with each other that I wish to explore.

I will neither deny the vast stylistic differences between them, nor the complexity of their connections to traditional India. Nor will I deny their internationalism. Husain's work carries the influences of Picasso and Klee, Goud's of Picasso (through Husain), Klee, and German Expressionism. Raza's has absorbed the geometrical elegance of Cézanne's Provence (where he lives and works for part of the year), Ramanujam's reveals influences of Impressionism and James Ensor. These facts simply show us that the four artists are modern and in the same boat with artists from the West. In our difficult post-modern world generally, connection with tradition is problematic and idiosyncrasy of style the norm. The contemporary world is international in that rigid cultural borders have broken down, with artists free to absorb influences from the world's domain. Not only are artists free to do this, they feel compelled to do it; as if in the light of artistic possibilities arising through cultural contacts, and social complications arising from world politics, artists can only respond to their own cultures in international terms. The results are that it is less than clear where one's own culture ends and another begins. The African mask and the Japanese woodcut are now western institutions just as cubism is an Indian one. If it means little to call the four artists on exhibition at The Phillips Collection Indian and contemporary, it means no more to call artists closer to home American (or German or French) and post-modern.

Yet in the midst of such cultural fluidities we

still want to claim that it means something more than superficial to call an artist Indian or German or American. This bespeaks our belief that in spite of the translucent borders between cultures there are differences in cultural details and orientation which run deep enough for us to mean something when we speak of the art of a place. Indeed the works on exhibition at the Phillips burst with the rhythms and life blood of India at least as strongly as they reveal world influences. Husain's deities spill across his canvases in vivid juxtapositions of brilliant Indian colors. Raza's semi-abstractions reverberate with the moods of Indian Ragas. Goud's tribal figures exist in villages where eroticism flows throughout the natural environment; Ramanujam's dreamwork turns magical twists on Indian symbols and figures. It is for similar reasons that we feel justified in calling German post-modern works German (or American ones American). The contemporary German painter Jörg Immendorff may have absorbed diverse influences in a world city (Berlin), but in pervasive ways his expressive intensity, anxiety, and heaviness of imagery bespeak a German heritage.

What binds Husain, Raza, Goud, and Ramanujam together is their common project of being contemporary to a developing India, an India whose democracy, world politics, and modern industry co-exist with articulate traditions, sedimented ways of life and non-modernizing villages. Call this a response to what they are. But since in the face of the present it is no longer clear who they are and what Indian is, their job is that of achieving a cultural identity: not by removing India's confusions of development (as if they could do this) but by finding amidst the throes of influence voices with which to acknowledge the situation of India. Finding such voices in current India is not easy. The first task has been to overcome the British school of portraiture which India had imposed upon it in the colonialist period. To this effect Husain, Raza, and others formed the Progressive Artists' Movement in 1947. However, expunging colonialist artistic styles does not guarantee that one can speak. It is easy to be overwhelmed by how much there is to say and how many artistic styles there are available to try to say it with. In the huge department store of world art where does one begin? The results can be incoherence, or, nearly as bad, mimicry (the situation in which one apes the voice of a master, losing oneself in the process and often speaking badly at that). Laxma Goud has noted the problem well in his *Sketchbooks:*

There are many schools of thought. . . . I like the Malwa school of painting and German Expressionism. . . . I also admire Paul Klee. . . . I see so much of Picasso/Husain in me but I want to uproot the mannerism from me . . . but they have become an integral part of my life system . . . so I shall make them resemble me.[1]

The position is to find influences which resonate with one's own concerns and to transpose forces already at work on one into terms which reflect and shape one rather than obliterating one.

The way these four artists achieve the voices they do is by making both Indian artistic traditions and western styles resemble them. They at once ring changes on Indian traditions in the light of modern India and ring changes on western styles in the light of Indian traditions and concerns. To understand how they achieve the voices they achieve—to understand how the Indian identity is being achieved and what it is—is

to follow through this transposition of forms from Indian tradition and the modern West. Because of this I will explore what these artists have to do with Indian traditions by way of exploring how they transpose traditions into a modern context. This exploration will also tell us something more specific about what they have to do with each other—indeed of what contributes to our calling them Indian—since their modes of transposition are marked by strong traits. I will begin with some remarks about Indian traditions.

Indian traditions are as varied as they are ancient. India is a country of over a hundred languages, with the Sanskrit-based languages to the north being linguistically closer to French and English than to their Dravidian-based southern neighbors to the south. Its religions include Hindu, Buddhist, Jain, Moslem, Sikh, and Christian. Its castes range from Brāhmin to Untouchable. Its geography spans the Himalayan mountains of Kashmir through the desert plains of Andhra to the semi-tropical canals of the deep south. Amidst such diversity of place and tradition one should not expect Indian culture to be homogeneous. Indeed if one is struck by the differences between the four artists on exhibition, one could have been equally struck by the vast differences between their traditional predecessors. The taut symmetries of the Chola bronze are as different from the crowded, boisterous paintings from Orissa as Raza is from Ramanujam. The voluptuous temples of Khajuraho are probably far more different from the Buddhist stupas of Sārnāth than Husain is from Goud. There is no one thing which makes Indian culture Indian: rather, Indian culture consists of a family of different things which are related in ways no less complex than the relations of the most convoluted family histories.

In spite of differences, both the works at the Phillips and their traditional counterparts tend to be related not only in numerous details but by strongly characterizing traits. Of particular importance among such traits are three. First, the tendency in Indian art is to completely dynamize and fill the artistic space; to put it in motion and make it an occasion for acts of transformation. Second, those works which use color use brilliant colors which envelop a space with symbolic and expressive value as opposed to serving as a filter for light. Third, Indian art models the human form in distinctly Indian ways. These traits link the contemporary works with their predecessors, and they govern ways in which influences are absorbed by Indian artists.

Raza

I will begin with the work of Raza. While Raza's elegant half-abstractions bespeak his home in the south of France, their rhythms, color, and symbolic values suggest Indian miniature painting, Indian music, Indian life and philosophy. The Indian miniature, India's most important form of traditional painting, has exerted strong influences on much of contemporary Indian art. When the Progressive Artist's Movement was formed in 1947, its members made a close study of the Rajput miniature. Rather than being concerned with overall perspective, the miniature tends to fill pictorial space with all sorts of figure and landscape elements organized through rhythm and theme. Its subtle details and rich colors create soft musical patterns akin to the Ragas of Indian music. Its details serve as thematic focal points, the primary theme being the

life and loves of Lord Krishna. Color is thus used to envelop a pattern of details with mood and texture rather than as a way of opening the picture towards a light source. Raza explicitly states his concern for the miniature:

I think Rajput paintings are some of the most dynamic paintings which exist today in Indian painting, in their plastic coordination of color and space, and their way of representing the Ragas of Indian music. . . . I don't want to approximate the two media, but I feel that they come as experience very near to each other. . . . To see that musical experience of nature in the paintings . . . in earlier centuries by the Rajput miniaturists . . . while not copying those works I'm trying to see to what extent a particular musical climate could be expressed in paintings that are almost the equivalent of classical music being played by musicians today.[2]

Raza's goal is to achieve musicality in paint along the lines of the miniature.

Raza's paintings *Rajasthan I* (cat. no. 57) and *Rajasthan II* (cat. no. 58) are modularly constructed, with each module representing the reduction of a miniature format. The musicality of these works derives from the tensions in them between pictorial edge and the rhythm and color of details contained within the edge. Against the architectural foundation of the edge is a crowded pattern of lines, semi-abstract forms, and rich red, black, and orange color fields which reverberate with musical motion and mood. Everything inside the edge is alive with counterpoint and dramatic cadence. It is as if the edge functions not unlike the repeating cycle of beats in a Raga—as an architectural basis within and against which development can be generated.

Raza's use of geometry as a musical foundation gives us a way of understanding how he trans-poses western artistic styles into Indian terms. His sense of architecture is influenced by Cézanne, specifically by Cézanne's ability to fix nature in architectonic terms (vis à vis the cone, triangle, etc.). Furthermore, he is influenced by the Cézannesque landscape of the south of France. He states: "My present canvases, in them you see that the painting stands like a stone house in Gorbio [where he lives], with the basement and upper stories . . . an architecture that stands on its foundation and its walls."[3] Yet unlike Cézanne, who wishes to extend his architectural presentation to even his portrayal of the figure (deadening the figure in the process), Raza uses architecture to contain and define musical space. The house is Gorbio, but inside it one finds India. Similar twists occur with his use of abstraction. Raza is thinking abstractly in that he is thinking in terms of the expressive values derived from juxtaposing blocks of color, but he is thinking non-abstractly in that his forms have the capacity to refer to or recall those of the miniature (its landscape and figure), and those of Indian nature and life. Raza himself is his most articulate spokesman:

I believe that my paintings are not wholly abstract, they are derived from nature. . . . You see the houses, the trees, the fruits and branches, the whole visual rhythm which is sensed by the eyes but brought over to the other senses, almost like a fabulous drama which is going on. . . . Whether you are in Udaipur [a Rajasthani city] or the lakes of Kashmir or a temple, there is a whole movement, the life is full of it . . . almost akin to classical Indian music.[4]

Raza understands Indian music itself to resonate with the movement of Indian life. His own paintings carry the rhythm of his particular

childhood in the forests of Madhya Pradesh where his father was a forest ranger. Of his childhood in the forests he has said this:

Nature and this pure existence of the Indian forest . . . has influence on any child born in its climate. . . . A human being should not forget that the only thing is nature. . . . As a child the night was very dangerous, very frightful; the dreams, the nightmares. . . . The tigers we used to have in the compound . . . sometimes panthers, leopards coming into the house. . . . If we had a cobra, Father would take a gun and shoot it. . . . There was both the fascination and the fear, even today I have an intense desire to visit the countryside.[5]

This sense of fluid, inviting, and somewhat terrifying space can be felt in the musicality of his pictures.

Raza's pictures possess a meditative dimension, but in a distinctly Indian sense of meditation. The act of meditation of importance to him is that of concentrating intensely on a focal point—what in India is called a Bindhu—in a way that both activates the energy of the meditator and directs him towards a state of clarity. Such meditation is not a state of forgetting the world, for under the concept of Bindhu one is also supposed to gain perspective on the forces and cycles of nature in the world. Indeed one finds black bindhu marks in many of his paintings. These are symbolic of the meditative dimension to his work; viz., how his paintings recall nature as well as contain the energies of nature itself. In this sense his is a true marriage of Indian philosophy and contemporary painting.

The vibrancy of Raza's works, and indeed of the works of all the artists exhibited at the Phillips, recalls the vibrancy one finds in any Indian city or village. In India, one is bombarded by a world of smells, colors, dust, and crowds. People are washing, feeding children, setting up shop, sleeping, eating, and driving at breakneck speed throughout the bursting, tumbling streets of India.

Buildings are disintegrating and being recycled, with the foundation of a temple now serving as a tailor shop or a place where water buffaloes rest. Every bit of space is invested with motion and recycled for new use in human or animal life. This spatial bombardment teaches us not merely that we come to India with values which may be culturally bound but that we come to it with perceptual expectations about the kind of visual, auditory, and kinesthetic space we find normal and natural.

The lesson is of course that Indians possess perceptual expectations which differ substantially from our own. The lesson extends to aesthetics in that Indian artists dynamize and fill their spaces in ways utterly natural to the boisterous spaces of India. If we fail to appreciate the connection between artwork and Indian perceptual expectations we will not recognize, for example, how deeply Raza's crowded inner pictorial spaces reflect ordinary Indian life. But we may also misconstrue entirely what it means for an Indian picture to have such crowded spaces. We will take such crowdedness as more chaotic and disorienting than it is actually meant by an Indian artist. Indian pictorial spaces may represent a confused culture in the throes of disorienting changes, but they also give voice to the ordinary spaces in which Indians feel relaxed and at home. The Indian street is as much the American living room as it is the place of confusion. The Indian pictorial space reflects that security as much as that confusion.

M.F. Husain

The work of Husain clearly illustrates the activated spaces of Indian life. His *Benares* series, in spite of its spareness of figures and simplicity of line, seems to reverberate with energy, movement, and color, bespeaking a line with singing power. I begin with it. Benares is the holy city on the river Ganges where the cremated ashes of the dead are thrown into that holy river to be returned to God. Pilgrims come to bathe in its waters. Benares is therefore stamped with the energy of transformation. This occurs in a burning north Indian sun which mixes with the smoke of burning bodies to envelop the space in a colored dome. Husain has magnificently captured this dome of color through his black backdrops, against which the white traced figures of Benares become sharply energized. At the same time figures and backdrop are partly merged because the figures are filled in with the same black of the backdrop. As there are no shadows, no light is filtered; color and figure exist in an enveloped and enclosed space of energy. The space seems cast as a dramatic enclosure where some kind of fate is being played out.

Husain more than any other Indian artist is concerned to study on canvas the place of fate in India. His concern is both with the particular role of fate in India and with Indian life as an exemplar of what is universal to human life. These concerns are linked through his appreciation of the fact that universals of human life are only exhibited through particular persons in particular contexts. Thus for him to show anything universal about human life is to make a study of the particular context of India. As in Greek tragedy, the universality derives from the connec-

tions we make between the fate exhibited in the particular context and our own—call that identification with the dramatic character. India is an exemplar of fate because its sense of "dharma" runs so deep. Despite modernizing pressures, India is a place where one's life is largely defined by one's caste, economic status, place, and sex. Moreover, Indians view their lives as inescapably fated by such roles. In India one's daily life, insofar as it is determined by fate and viewed by one as fated, already has a cosmic dimension. In *Cage III* (cat. no. 22) Husain is concerned to portray the fate of women in India. Under the concept of Shakti, women exist solely as the energy of man. Their lives are ordained to be sacrificial. The women in Husain's picture are interlocked as four sides of one woman through a series of interlocking cubist planes. Their faces are largely obliterated, as if their identities consist only in how they are projected in space. These are the four roles of women in India, into which these figures are rigidly locked. Husain's genius is to show us that their cage is Indian life by projecting them into a crowded visual space (the spaces of Indian life) *and* by projecting those spaces as spaces of utter confinement. Not only are the women locked in, there is no possible place from which they could make an exit in this filled, crowded painting.

The universality of this picture derives from how much the fate of women in other places is similar (as it probably is). But it also derives from the connections the picture causes us to draw between this cage of women and other cages in other places. It forces us to recall how pervasively the world encages us in roles, economic prisons, psychological states, and many other situations. Indeed at its most abstract level,

Husain's picture can force us to remember what we forget: that we are shaped by the totality of our place and time. We are inescapably contemporary. This message with its existentialist dimension brands Husain's work as not merely about the persistence of ancient India in the present but also about what the modern world knows of the nature of its own existence.

Husain has been increasingly concerned with how the forces of nature, society, and politics shape one's fate. This concern has led him to rethink the great Indian epics—the *Mahābhārata* and the *Rāmāyana*. He has long been drawn to these epics as a way of "finding again the symbols and roots so familiar to the village people, the majority of people in India."[6] What he has found is that the symbols from these epics can be used to speak about contemporary conflicts. His *Hanuman* series (cat. nos. 27, 28, and 29) is about our contemporary yearnings for a superhero to save us from disaster. The story of Hanuman (the monkey god), from the *Rāmāyana* is this: Laxman lies sick. He can be cured only by an herb found on a nearby mountain. Hanuman, being kind, goes to get the herb, but not being very bright, he forgets which herb to retrieve by the time he arrives at the mountain. So with his enormous strength, he brings back the entire mountain. In a world where nuclear conflicts between superpowers have taken on the epical proportions of movies (*Star Wars*) which in turn become political strategies, Husain is addressing both our ancient desire for a superhero who will magically deliver us from such conflicts, and what such a person might be like. Hanuman is cast with his head facing backwards over his shoulder. In the midst of action he is bewildered about what it all means. Yet he acts and acts rightly. This is a comment with a comical touch about the kind of qualities it takes to make a hero (intelligence is not necessarily one of them) and about the relation between the hero and us. Hanuman represents our mortal bewilderment with the epical dimension of our own political fate.

Husain's *Hanuman* series also allows us to understand another aspect of the Indian sense of space. Many of the pictures in the series are split down the middle or across a central diagonal. Husain's cubism juxtaposes spatial planes and invests them with dynamism. His cubist renderings give voice to the spaces Husain finds normal and natural. Space in India is not only sensed as dynamized and filled, but also as composed of natural juxtapositions and splits. A busy Rajasthani city stands alongside the vast silence of the Rajasthani plains. Amidst the movement of an Indian street, an animal will wander lazily oblivious to it all, or a yogi will stand on one foot, claiming it all to be oblivion. A garishly painted novelty shop will stand next to a decaying moghul monument plastered with huge film posters. Furthermore, the culture is defined through rigid juxtapositions of caste, religion, economic status, and sex. Against that background Husain has transposed cubism into Indian terms, making cubist forms into dancing, juxtaposed planes. In fact such combinations extend to every aspect of his work. He will juxtapose color fields, figures, and every conceivable intermixture of these elements.

Laxma Goud

Laxma Goud's pencil drawings contain large amounts of open space, befitting the tribal area in which he grew up. His figures are solitary. When

more than one is found in a drawing they rarely seem to communicate. Often one is silhouetted against the background of the other, linked only by an invisible diagonal line, as if they have passed hundreds of times, but taken no notice of each other. However, his figures do not appear lonely or alienated; rather, they have the simple presence of nature itself. They appear to be as much a part of the natural world as the plants, animals, objects, and Vedic gods also found in his drawings. Goud's vision is that of a village where every element is continuous with every other. Thus, while his works do show the juxtapositions of India by way of darkened pictorial elements set against a light penciled background, all elements seem equally capable of being set in relief. Sometimes the face of a foreground figure, or an article of clothing, or a tree is enlivened as a phallic organ. In Goud's world the various elements are continuous in character not merely by virtue of their presence in the landscape but also their shared organic potentialities. His works are dynamized by the erotic energy that flows through the village as a whole. Ancient Vedic Yakshis (female fertility gods) and Yakshas (guardians of treasures) crop up everywhere. Trees turn into huge phalluses, phalluses burst out of houses. All is alive through the same forces of soul. When figures in his work do regard one another (cat. no. 9), their regard is directly sexual, like that of an animal regarding one of its mates.

Goud has remarked that in such tribal areas sexuality is as open and natural as breathing, farming, eating and the growth of crops and trees. He makes the point through an anecdote:

I took my work to my own village when a film was being made by one of our German friends. . . . He wanted to experiment. . . . He wanted to see how people reacted to their very heavy erotic element. . . . He could not believe that in the villages men and women talk openly about the erotic. . . . He held my works of huge phalluses and beautiful women gazing at them in lush green with water buffalos. . . . A woman from the village came and looked and said, 'ya, ya, ya, I am like that woman and that buffalo, it's nice '. . . . The woman could identify herself in the picture.[7]

In a world of daily erotic directness one is free to associate all forms of organic growth and objective power with the erotic, for each is equally wonderful and equally banal. Goud entwines figures with their ornaments, as if they are stitched from the same cloth, and these with phallic trees, plants and animals. Figure, ornament, tree, and stone are clumped together as if they were tufts of landscape. The village takes on the natural economy of a single cell, in which the various parts exist in various states of activation and stillness. These disequilibriated groupings of figures, trees, and objects are balanced by single entities or similar groupings. The village is nature always in the throes of entropy. Within its natural cycles it discards nothing. The earlier pencil drawing of several objects and a rope turns into later drawings in which these objects become part of the larger landscape, as if Goud himself refuses to discard any artistic detail.

These pictures can be disturbing—as disturbing as the real world, which conceals nothing. The figures are stitched, leathery, and never free of blemishes. They can suffer. Yet they are not in the end either alienated or afraid, since they are unashamed and unconcealing. They are exactly as one sees. Out of this directness comes both

their dignity and the humanity of Goud's own work. When asked about certain unattractive elements in his works, Goud made this reply:

We all have a certain unattractive self. Many artists struggle to purge it, I do not. . . . Like a good mother and father, if they happen to have a crippled child, they are not afraid of it. . . . One has given birth to it, one cannot part from it. . . . Likewise you take me for myself. . . . You cannot eliminate certain parts of me, it is impossible, if you have me you have to have me with everything, to do otherwise is not to be an artist [nor a human].[8]

In Goud's full acknowledgment of the total life of the village is his full tolerance and respect.

Goud's unusual ability to portray forms in the midst of organic growth and change, and to convolute them in clumps, is used not only to represent the village as a manifestation of nature, but also to convey the special sort of storytelling he witnessed as a village child. Of this he says:

There were wonderful storytellers in my village, they would create an imagined world. . . . Once upon a time there was a king and he had to cross seven seas. . . . The storyteller would make beautiful images. . . . There was only a visual image in it . . . words become nothing. . . . I used to travel with those people. . . . I used to feel as if I were flying. . . . I don't think even dream achieves it. . . . The child will then imagine. . . . yes the seas must have been like this . . . such imaginings bear a lot of impact on my work.[9]

Goud's organismic forms are as much the product of free storytelling cum imagination as they are representations of village life. There are ways of making line come alive, of creating growing worlds of art. Indeed in certain respects Goud's work is itself like a piece of village life in both its banality and its wonder.

Goud gives us an opportunity to consider ways in which the Indian modeling of figure differs from that of the West. Such differences are spelled out both in the manner of posturing a figure and the elements of the figure which are given special attention. In terms of posturing Goud's figures bend in non-western ways. When they bend, they bend in three places, from the knees, the waist, and the shoulders. The knees may be dipped forward while the waist twists and the shoulder is pushed upwards (cat. no. 3). A westerner would typically bend in one smooth gesture from the knees through the shoulders. One finds this mode of modeling figures in Husain as well—in, for example, the twisting of Hanuman (cat. no. 15). In terms of what parts of the figures are emphasized, I have already remarked that Husain tends to obliterate the face for his own reasons. I have not remarked that he tends to emphasize the hands, befitting the extraordinary subtlety with which the Indian hands are used to gesture and their importance in a manual culture. In addition to the pelvic area and sexual organs, Goud tends to emphasize the feet (as does Husain). He remarks about the importance attached to the feet in India through another anecdote:

There are very important things like the feet, the hands, the way we sit. . . . The feet take so much pressure; I can recognize people by looking at their feet, I don't have to see their face, I can tell what profession they have. When a child is born what I do and what my father did was to look at the tender hands and tender feet. . . . Then I would say, 'oh, they're exactly like her mother' . . . not looking at the face at all.[10]

One can see this in a picture such as *Untitled* (cat. no. 9), where the woman's interest in the

man is spelled out in part through her hands and feet which are turned towards him and both his and her feet are highly arched, suggesting strength, suppleness and mobility.

Ramanujam

Of the four artists in this exhibition, it is Ramanujam's work which is the most completely given over to fantasy. Ramanujam painted a personal mythology in which he was free to live what he could otherwise only dream. His extraordinary powers of invention allowed him to fashion a mythical world filled with images from a variety of sources, Indian and Western. He lived and worked at Cholamundal, in Madras, where a colony of artists follow folk traditions. Ramanujam's serpents, gods, animals, and magical colors reflect the spirit and style of Indian folk art. Against a softly burning orange color a single figure rides a beast whose head is as elongated as that of a lamb and whose tail is that of a serpent. The rider and animal are set squarely in the middle of the pictorial space, with little regard for perspective (cat. no. 34). The huge, bursting monster/god figure (cat. no. 37) and the lovely female god figure (cat. no. 44) similarly recall the oversized puppets and papier-maché gods carried on floats during folk celebrations. But Ramanujam's dreamwork rang its changes on everything he absorbed. From Impressionist painting and from a picture book of the architecture of Venice which impressed him greatly, he absorbed a sense of how to float architectural forms in areas of washed color (cat no. 33). Apparently he responded to the entrancing delicacy of Venice and its ability to carry one into the past, for one finds in nearly every one of his pictures some architectural structure suggesting an Indianized rendition of Venice. In one painting (cat. no. 35), for example, he takes a Venetian arch form and turns it into a cavernous entrance to a place of celebration. As a fan of Tamil films, films with complex plots and garish romanticism, he sometimes seems to construct elaborate mise-en-scénes, as if for some fabulous drama (cat. no. 43).[11]

Ramanujam's mythology often concerns travel, a special kind of travel responding to his longing for marriage and companionship. Unfortunately, he was very short, deformed, and a stutterer. Since these traits all but precluded his finding a woman, he could only travel with an imagined woman in his paintings. In each of them he appears with a moustache and beady eyes. He is invariably the only male to appear, accompanied by a woman or a complex woman/god/animal figure. He may be riding with her, or on her, or he may be seen next to some figure of movement such as a bird or serpent. But this is not ordinary travel, it is the travel of dreams and incarnations. Ramanujam used to claim a wonderful dream life, with vivid images of flying, entering into caves, and other such activities. These dreams enter his pictures through the flying figures (cat. no. 38) and cavernous entrances (cat. no. 35). They also reflect Hindu mythology, in which each god has his or her "avatar" or vehicle of incarnation. Shiva's is the phallus, Vishnu's (the god of preservation) the half-man/half-bird figure. By riding into his pictures and appearing in them in transformed form (as a serpent, a bird, etc.), Ramanujam is in effect incarnating himself in his pictures in order to live a golden life with a woman he could otherwise never find. In one painting (cat. no. 39), cast in

warm brown, is a strange dog-figure whose sad cheeks are dying to be touched by another human being. That is himself, as his moustache tells us. The women with whom he is incarnated are equally striking and tender: one female figure (cat. no. 44) wears a crown, befitting a princess; another (cat. no. 33) is like a reclining mermaid floating above a Venetian canal.

Ramanujam's artistic dreamwork could absorb Impressionism, folk symbols, Indian films, picture books of faraway places, and memories from dreams. From such bricolage he invented a place which rather than being about life would simply be a place where he could be alive. Yet such invention, we should recall, is in the mainstream of Indian tradition, as any of Goud's village storytellers would tell us.

What makes these artists contemporary is their ability to achieve Indian voices in the face of modern India and the modern world. Speaking of music, vitality, fantasy, and difficulty, they achieve their voices by transposing their traditions in the light of modern predicaments and artistic influences, and by stamping such influences with distinctly Indian traits. This achievement of a voice is for them an achievement of identity. For us, in revealing how the Indian past is part of the present and how world influences become Indian, they tell us no less than what it means to be Indian.

Notes

1. LAXMA GOUD, *Sketchbooks*, unpublished manuscripts, 1980.
2. SAYED HAIDER RAZA, interview by Chester Herwitz.
3. *Ibid.*
4. *Ibid.*
5. *Ibid.*
6. MAQBOOL FIDA HUSAIN, interview by Chester Herwitz.
7. LAXMA GOUD, interview by Chester Herwitz.
8. *Ibid.*
9. *Ibid.*
10. *Ibid.*
11. The influence of Tamil films on Ramanujam's work was related to Chester Herwitz by Vasudev, an artist who works at Cholamundal and had been a colleague of Ramanujam.

28

Village life, its people and scenes, has remained Laxma Goud's deepest inspiration, lovingly recaptured in drawings and prints. Born in 1940 in Nizampur, Andhra Pradesh, Goud attended the College of Fine Arts and Architecture in Hyderabad. In 1963 he was awarded a scholarship to study mural painting at the Faculty of Fine Arts, Baroda, where he became a student of K. G. Subramanyan. While there, he began to specialize in printmaking. Since 1965 he has regularly exhibited his drawings, watercolors, and prints in his native country as well as at the Tokyo Print Biennale and in the exhibition "Figurative Indian Artists" that traveled to Warsaw, Budapest, and Belgrade. In 1977 Laxma Goud represented India as a Delegate Artist at the São Paulo Biennale.

In 1982, after completing a large mural of etched copper and brass in Madras, Goud participated in the Festival of India exhibition "Contemporary Indian Art" at The Royal Academy of Arts, London. He has worked and exhibited in Germany and had his work included in group shows in Calcutta, New Delhi, and Madras in 1984, followed by a 1985 solo exhibition at Rabindra Bhavan, which houses the Sangeet Natak Academy in New Delhi.

Laxma Goud lives in Hyderabad, where he works as a graphic artist for television and produces prints in his own workshop.

The son of a forest officer, Sayed Haider Raza was born in 1922 in the village of Barbaria, Madhya Pradesh. In 1947 he was a founding member of the Progressive Artists' Group of Bombay, where he studied art at the Sir J. J. School of Art from 1946 to 1947, the year he also had his first one-person show in Bombay. While attending the Ecole Nationale des Beaux-Arts in Paris from 1950 to 1953, he exhibited in France, and during the 1960s his work was presented in numerous solo and group exhibitions in France, India, Canada, and Germany.

Raza participated in the biennales of Venice (1956 and 1958), Paris (1957), São Paulo (1959), and the New Delhi Triennale (1956). At Menton he received the 1972 Prix de la Biennale. While a visiting lecturer at the University of California at Berkeley in 1962, Raza had his first one-person exhibition in the United States in Palo Alto, California.

In recent years Raza has participated in the 1982 Festival of India in Great Britain with several works included in the exhibition "India: Myth and Reality," held at the Museum of Modern Art, Oxford, and "Contemporary Indian Art," shown at The Royal Academy of Arts in London. The 1983 Salon de Mai of Paris featured his work, as did a solo exhibition in Bombay in 1984, and the 1985 presentation "Artistes Indiens en France" at the Centre National des Arts Plastiques in Paris. Raza lives and works in Paris, the city that honored him with the Prix de la Critique in 1956.

K. G. RAMANUJAM

MAQBOOL FIDA HUSAIN

Born in 1941 to an orthodox Brāhmin family in Madras, K. G. Ramanujam was severely impaired by birth defects in hearing and speech. Through his art, however, he escaped into a colorful world of fable and imagery inspired by Indian myths, children's books, and his own vivid fantasy.

When his talent became evident, his father took him to Madras, where Ramanujam received a scholarship at the Government College of Fine Arts, working as a student and protégé of K. C. S. Paniker until his graduation in 1966. In 1964 the young artist had moved to the Cholamandal Artists' Village, a unique cooperative with studio residences founded by Paniker, where about thirty artists could live and work on the Mahabalipuram seafront near Madras. Although Ramanujam's work—colorful oils and watercolors, often depicting the artist himself—began to receive attention, it was never exhibited during his lifetime. Feeling increasingly despondent because of the isolation caused by his handicaps, he eventually succumbed to alcoholism and died by suicide in 1973.

A painter, printmaker, photographer, and filmmaker, Maqbool Fida Husain was born in 1915 in Maharashtra, Pandharpur. After briefly studying art in Indore, he moved to Bombay in 1937, where he became a painter of cinema billboards.

Husain had his first one-person exhibition in Bombay in 1950. Beginning in the 1950s, he established a lifelong pattern of extensive international travel. He participated in the 1953 Venice Biennale, the 1959 São Paulo Biennale, and the Tokyo Biennale of the same year, where he won a first-place award. His work was first shown in the United States at India House, New York, in 1964, and in 1971 he again participated in the São Paulo Biennale, honored as a Special Invited Artist together with Pablo Picasso.

Aside from numerous exhibitions in India and abroad, he was given a major retrospective in 1973 at the Birla Academy of Art, Calcutta, and was represented in the 1982 Festival of India in Great Britain with works shown at The Royal Academy of Arts, London; the Museum of Modern Art, Oxford; and the Tate Gallery, London.

Husain's work as a filmmaker was honored in 1968 when he received the Golden Bear award from the city of Berlin for his film "Through the Eyes of a Painter." In recent years, while exhibiting widely throughout India, the artist has ever expanded his mastery of different techniques and media, working as a photographer and exhibiting works on plexiglass at a 1984 exhibition in Hannover, Germany. Since then he has completed a mural in New Delhi and a mural and ceiling decoration in Bombay.

Catalogue

Dimensions are in inches and centimeters, height preceding width. For works on paper, measurements refer to the image size.

LAXMA GOUD

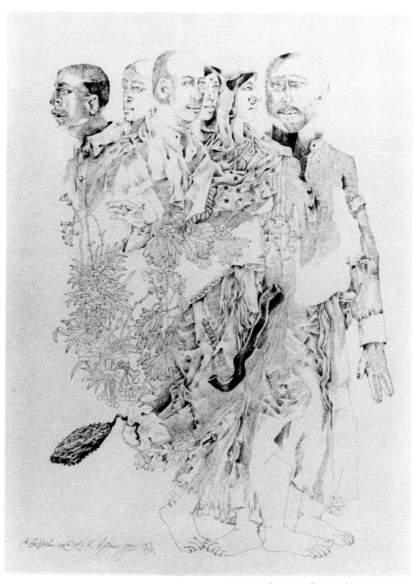

2. Laxma Goud, *Untitled*, 1978

1.
Untitled 1976
Pencil on paper
20 x 30 (50.8 x 76.2)

2.
Untitled 1978
Pencil on paper
12 x 9 (30.5 x 22.9)

3.
Untitled 1978
Pencil on paper
10 x 14 (25.4 x 35.6)

4.
Untitled 1978–80
Pencil and colored pencil on paper
11 x 14 (27.9 x 35.6)

5.
Untitled 1980
Pencil on paper
19 x 25 (48.3 x 63.5)

6.
Untitled 1982
Pencil on paper
25 x 19 (63.5 x 48.3)

7.
Untitled 1983
Pencil on paper
15 x 18 (38.1 x 45.7)

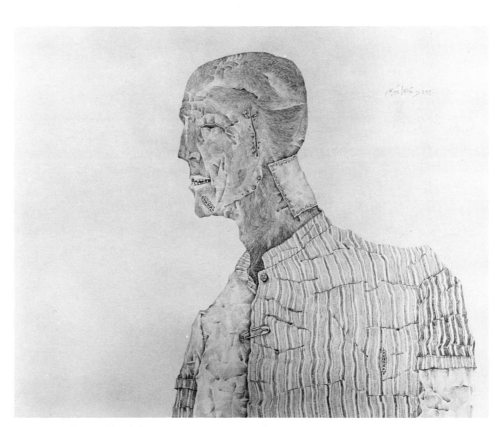

4. Laxma Goud, *Untitled*, 1978–80

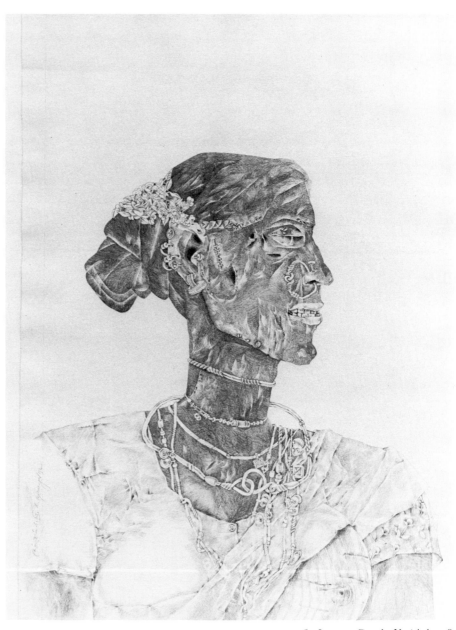

6. Laxma Goud, *Untitled*, 1982

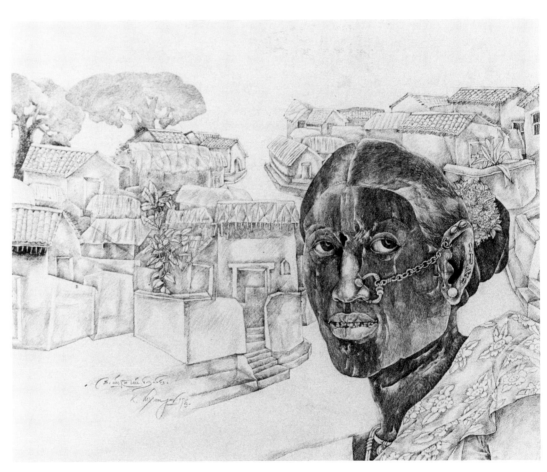

7. Laxma Goud, *Untitled*, 1983

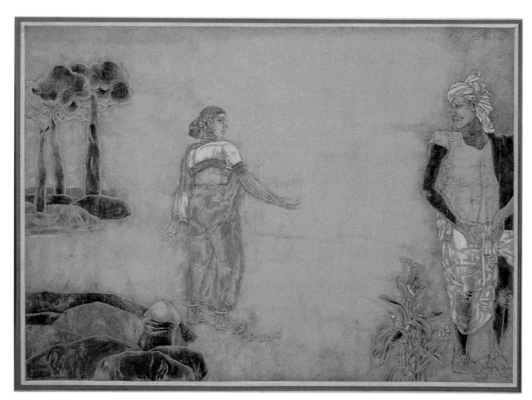

10. Laxma Goud, *Untitled*, 1983

8.
Untitled 1983
Pencil on paper
18 x 20 (45.7 x 50.8)

9.
Untitled 1983
Pencil and colored pencil on paper
18 x 37 (45.7 x 94.0)

10.
Untitled 1983
Pencil and colored pencil on paper
17 x 23 (43.2 x 58.4)

11.
Untitled 1983
Pencil on paper
20 x 16 (50.8 x 40.6)

12.
Untitled 1983
Watercolor on paper
21 x 15 (53.3 x 38.1)

13.
Untitled 1983
Watercolor on paper
29 x 10 (73.7 x 25.4)

14.
Untitled 1983
Watercolor on paper
21 x 15 (53.3 x 38.1)

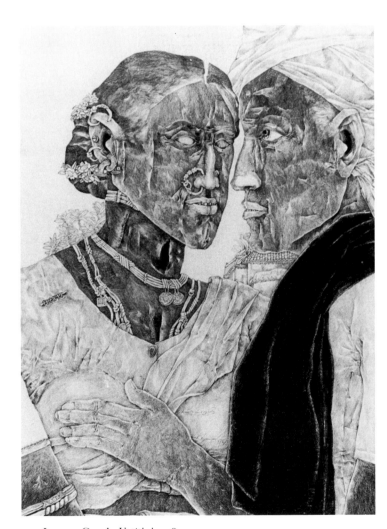

11. Laxma Goud, *Untitled*, 1983

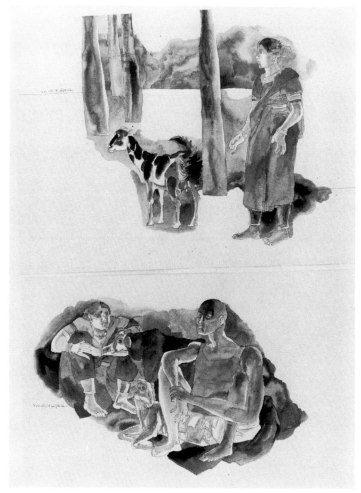

12. Laxma Goud, *Untitled*, 1983

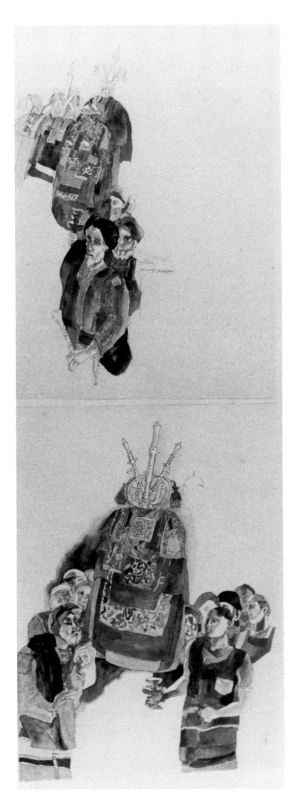

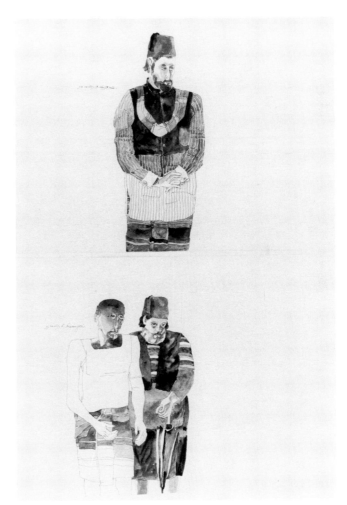

14. Laxma Goud, *Untitled*, 1983

13. Laxma Goud, *Untitled*, 1983

40 **MAQBOOL
FIDA
HUSAIN**

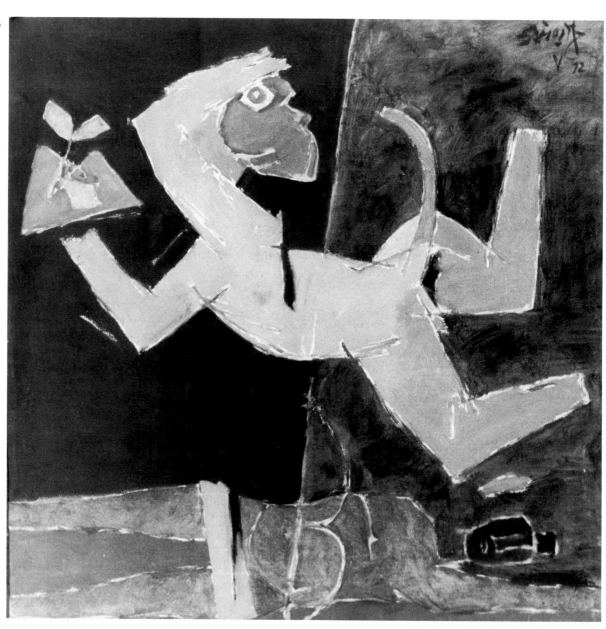

15. Maqbool Fida Husain, *Hanuman*, 1972

15.
Hanuman 1972
Oil on canvas
50 x 50 (127.0 x 127.0)

16.
Benares III 1973
Serigraph on paper
26 x 34 (66.0 x 86.4)

17.
Benares IV 1973
Serigraph on paper
26 x 34 (66.0 x 86.4)

18.
Benares V 1973
Serigraph on paper
34 x 26 (86.4 x 66.0)

19.
Benares VI 1973
Serigraph on paper
26 x 34 (66.0 x 86.4)

20.
Benares VII 1973
Serigraph on paper
26 x 34 (66.0 x 86.4)

21.
Benares VIII 1973
Serigraph on paper
26 x 34 (66.0 x 86.4)

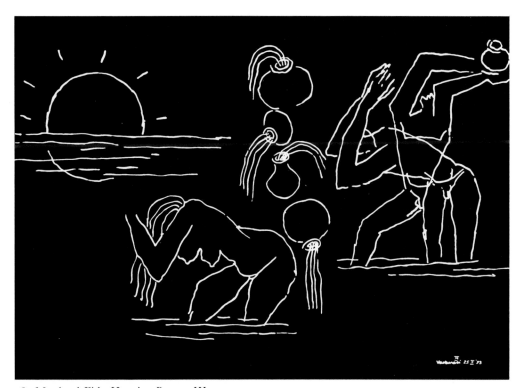

16. Maqbool Fida Husain, *Benares III*, 1973

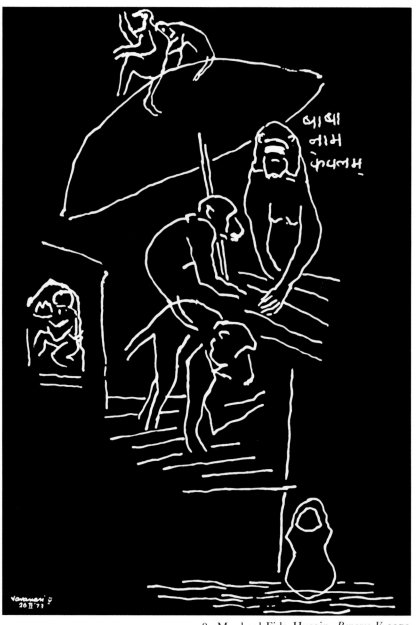

18. Maqbool Fida Husain, *Benares V,* 1973

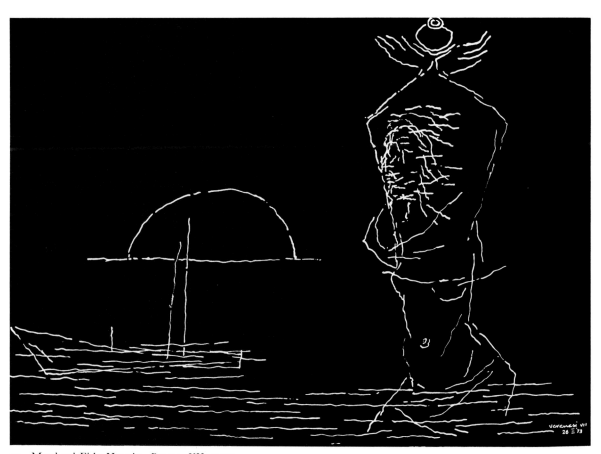

20. Maqbool Fida Husain, *Benares VII*, 1973

22. Maqbool Fida Husain, *Cage III*, 1973

22.
Cage III 1973
Oil on canvas
88 x 75 (223.5 x 190.5)

23.
Lakshma ca. 1973
Acrylic on canvas
88 x 55 (223.5 x 139.7)

24.
Arjuna and Washington 1976
Acrylic on canvas
50 x 44 (127.0 x 111.8)

25.
Cyclonic Silence 1977
Oil on canvas
48 x 96 (121.9 x 243.8)

26.
Cyclonic Tomb 1977
Watercolor on paper
28 x 21 (71.1 x 53.3)

27.
Hanuman Nine 1981
Watercolor on paper
14 x 21 (35.6 x 53.3)

28.
Hanuman Ten 1981
Watercolor on paper
15 x 22 (38.1 x 55.9)

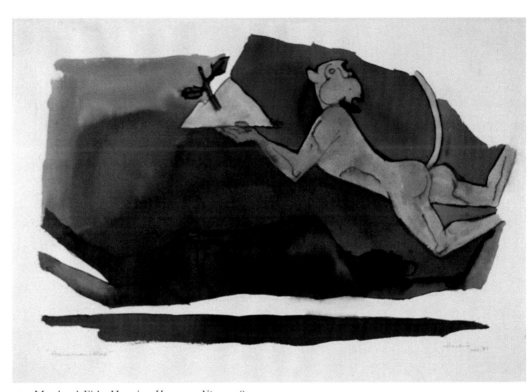

27. Maqbool Fida Husain, *Hanuman Nine*, 1981

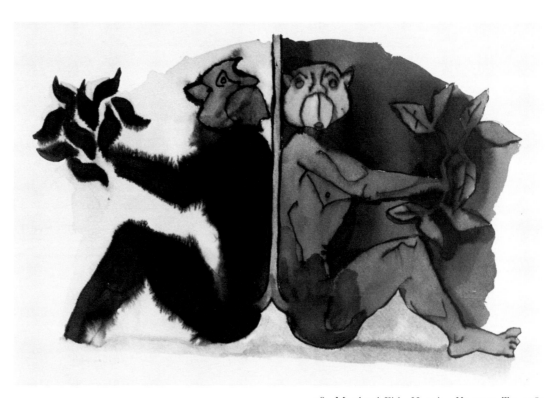

28. Maqbool Fida Husain, *Hanuman Ten*, 1981

29.
Hanuman Thirteen 1981
Watercolor on paper
13 x 20 (33.0 x 50.8)

30.
Kailash-Pati 1981
Watercolor on paper
15 x 22 (38.1 x 55.9)

31.
Untitled 1982
Watercolor and tempera on paper
19 x 14 (48.3 x 35.6)

32.
Ku-vadhu 1983
Watercolor and tempera on paper
22 x 25 (55.9 x 63.5)

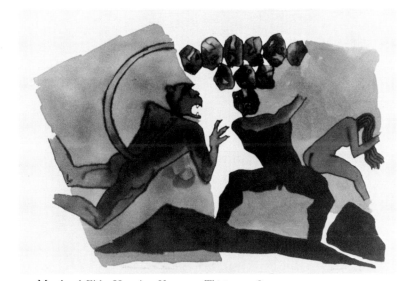

29. Maqbool Fida Husain, *Hanuman Thirteen*, 1981

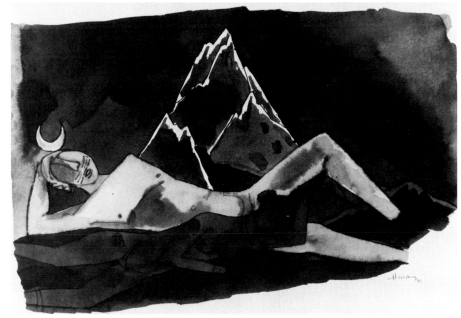

30. Maqbool Fida Husain, *Kailash-Pati*, 1981

K. G. RAMANUJAM

33.
Untitled 1968
Oil on canvas
19 x 29 (48.3 x 73.7)

34.
Untitled 1968
Oil on canvas
20 x 26 (50.8 x 66.0)

35.
Untitled 1969
Oil on canvas
17 x 24 (43.2 x 61.0)

36.
Untitled 1969
Oil on canvas
29 x 18 (73.7 x 45.7)

37.
Untitled 1969
Oil on canvas
41 x 35 (104.1 x 88.9)

38.
Untitled ca. 1970–72
Oil on canvas
21 x 26 (53.3 x 66.0)

39.
Untitled ca. 1970–72
Oil on canvas
23 x 15 (58.4 x 38.1)

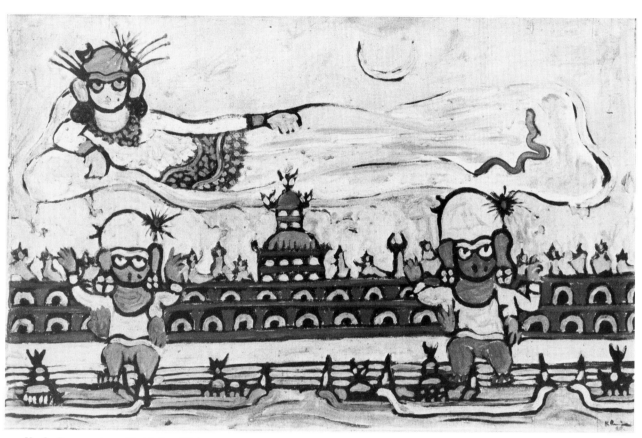

33. K. G. Ramanujam, *Untitled*, 1968

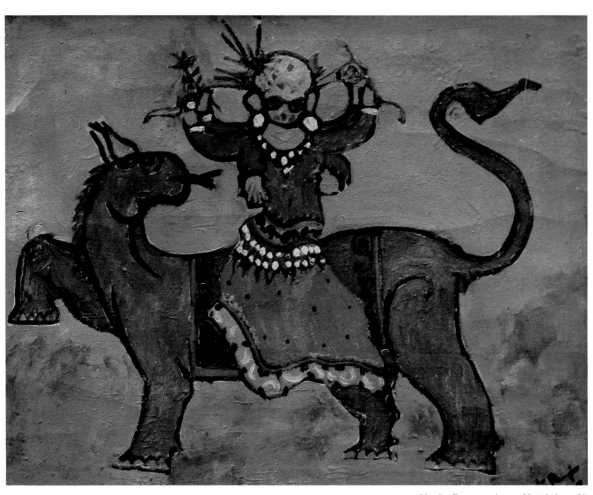

34. K. G. Ramanujam, *Untitled*, 1968

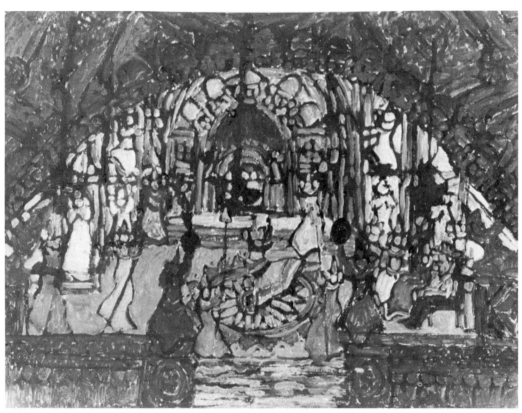

35. K. G. Ramanujam, *Untitled*, 1969

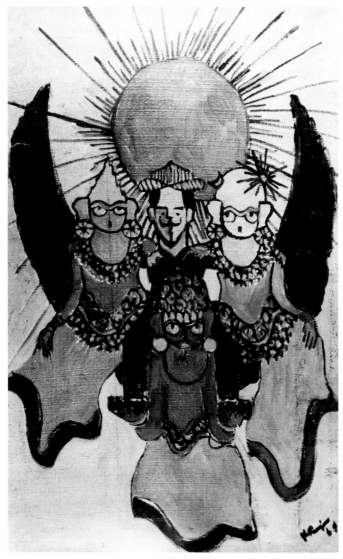

36. K. G. Ramanujam, *Untitled*, 1969

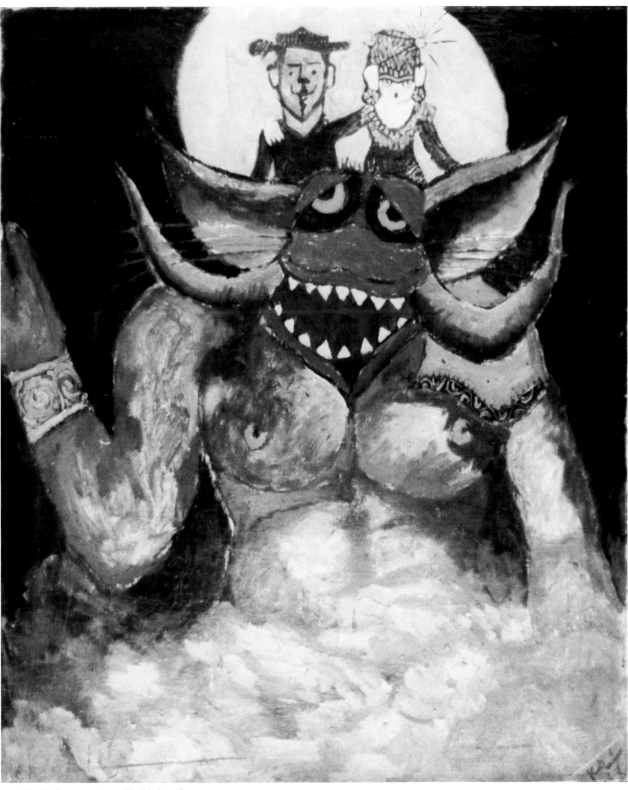

37. K. G. Ramanujam, *Untitled*, 1969

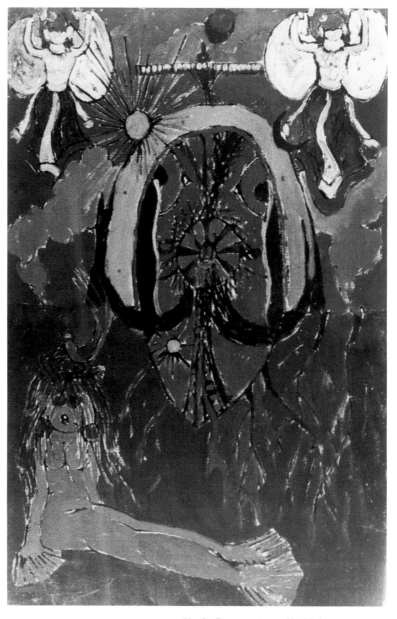

39. K. G. Ramanujam, *Untitled, ca.* 1970–72

40.
Untitled 1972
Tempera and ink on paper
9 x 6 (22.9 x 15.2)

41.
Untitled 1972
Tempera and ink on paper
12 x 5 (30.5 x 12.7)

42.
Untitled 1972
Tempera and ink on paper
8 x 7 (20.3 x 17.8)

43.
Untitled 1973
Oil on canvas
18 x 34 (45.7 x 86.4)

44.
Untitled 1973
Oil on canvas
19 x 16 (48.3 x 40.6)

45.
Untitled ca. 1973
Oil on canvas
16 x 34 (40.6 x 86.4)

46.
Untitled undated
Watercolor and ink on paper
11 x 15 (27.9 x 38.1)

47.
Untitled undated
Watercolor and ink on paper
9 x 14 (22.9 x 35.6)

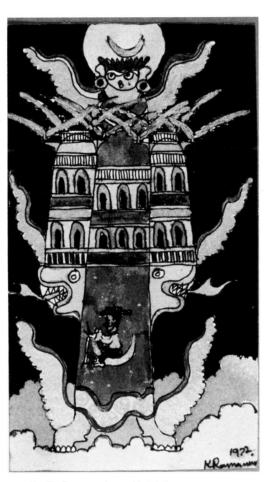

40. K. G. Ramanujam, *Untitled*, 1972

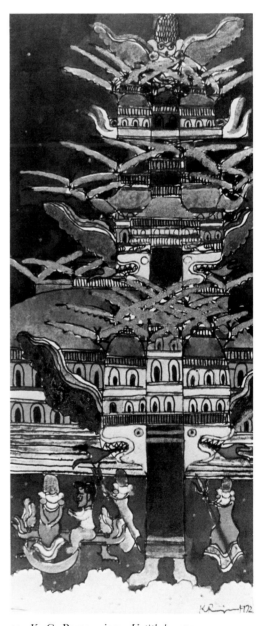

41. K. G. Ramanujam, *Untitled*, 1972

56 *K. G. Ramanujam*

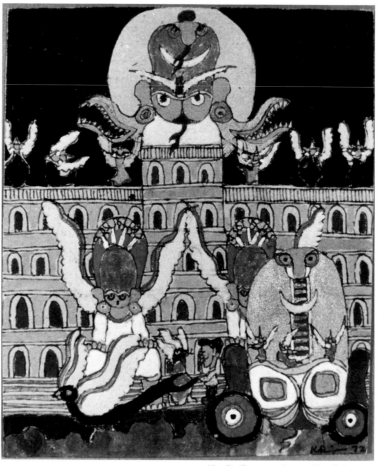

42. K. G. Ramanujam, *Untitled*, 1972

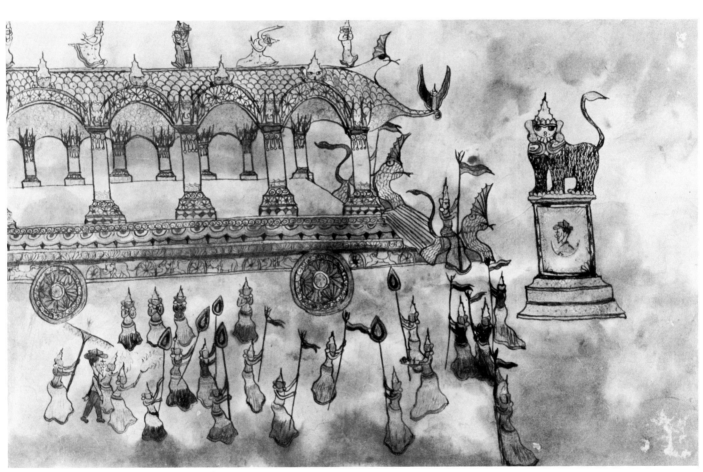

47. K. G. Ramanujam, *Untitled*, undated

58 **SAYED HAIDER RAZA**

48. Sayed Haider Raza, *Nuit Provençal*, 1964

48.
Nuit Provençal ca. 1964
Oil on canvas
57 x 44 (144.8 x 111.8)

49.
Heart Is One 1964
Oil on canvas
56 x 42 (142.2 x 106.7)

50.
P567 1964
Oil on panel
13 x 12 (33.0 x 30.5)

51.
Untitled 1964
Oil on panel
10 x 15 (25.4 x 38.1)

52.
I Will Not Die 1966
Oil on panel
7 x 21 (17.8 x 53.3)

53.
L'été 1967
Oil on canvas
59 x 59 (149.9 x 149.9)

50. Sayed Haider Raza, *P567*, 1964

60 *Sayed Haider Raza*

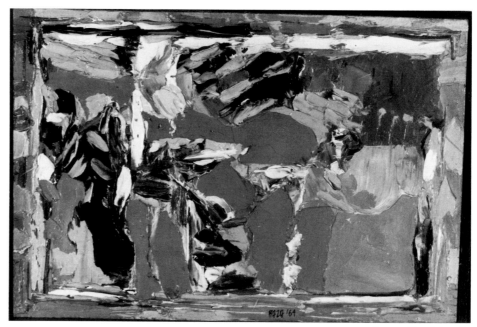

51. Sayed Haider Raza, *Untitled*, 1964

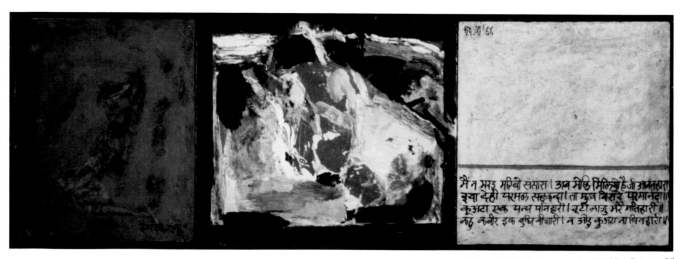

52. Sayed Haider Raza, *I Will Not Die*, 1966

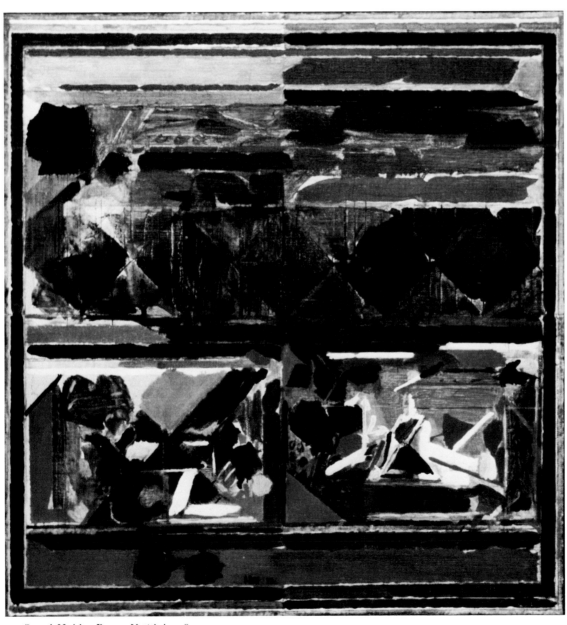

54. Sayed Haider Raza, *Untitled*, 1982

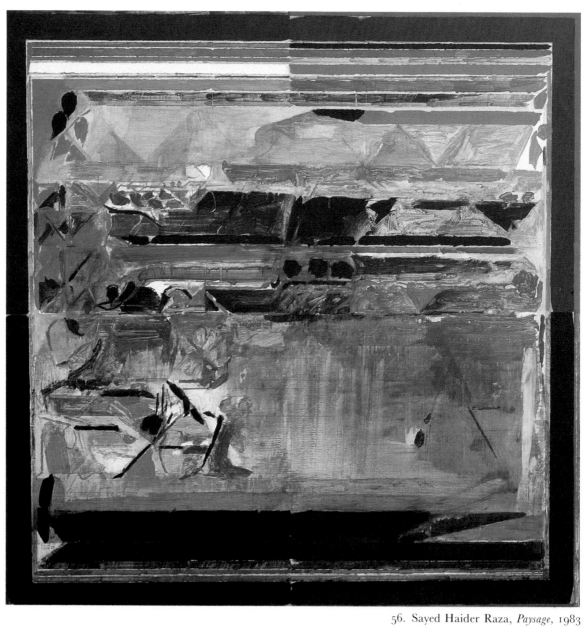

56. Sayed Haider Raza, *Paysage*, 1983

54.
Untitled 1982
Acrylic on canvas
26 x 20 (66.0 x 50.8)

55.
Bindu, La Terre 1983
Acrylic on canvas
62 x 31 (157.5 x 78.7)

56.
Paysage 1983
Acrylic on canvas
47 x 47 (119.4 x 119.4)

57.
Rajasthan I 1983
Acrylic on canvas
60 x 60 (152.4 x 152.4)

58.
Rajasthan II 1983
Acrylic on canvas
69 x 69 (175.3 x 175.3)

59.
Untitled undated
Color lithograph
on paper
26 x 26 (66.0 x 66.0)

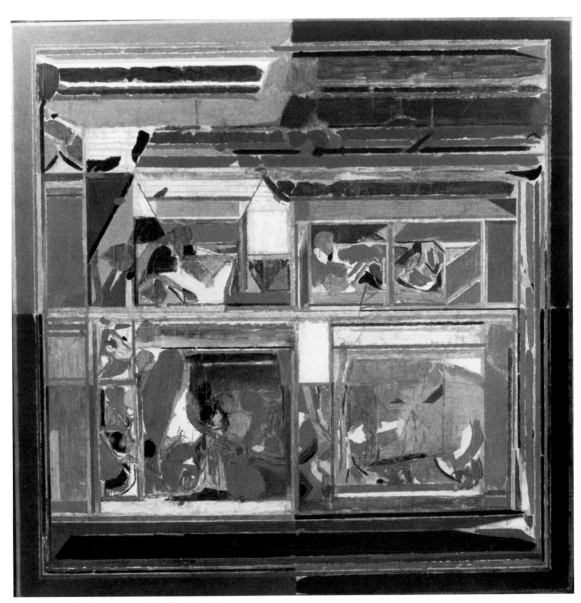

57. Sayed Haider Raza, *Rajasthan I*, 1983

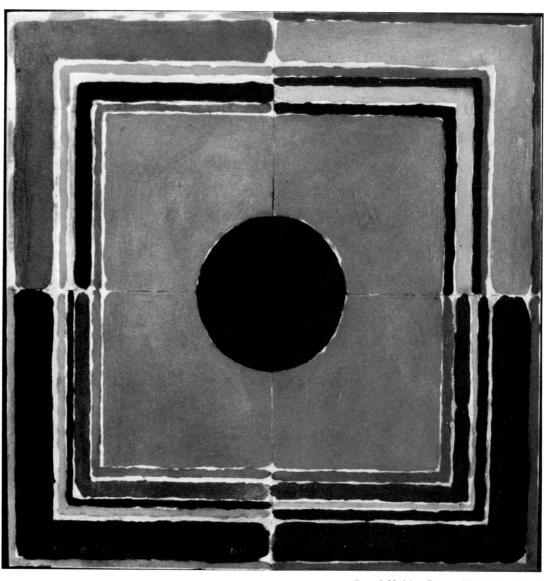

59. Sayed Haider Raza, *Untitled*, undated